Secrets of Brush Calligraphy

You CAN do it!

Brush lettering is everywhere and now it's your turn to join in. I'm going to teach you the secrets of brush calligraphy so that you can create a piece of work so stunning, you'll be dying to start work on the next one.

I've broken this book down into seven simple projects so that by the end, you'll have worked through all you need to know to create your own beautiful brush calligraphy with confidence.

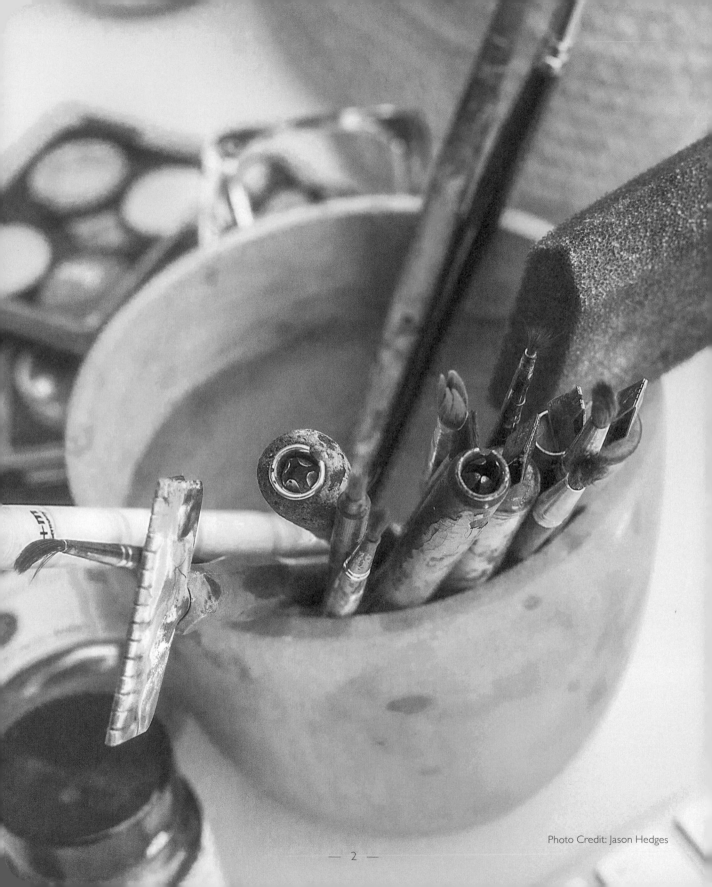

Photo Credit: Jason Hedges

Contents

THE SECRETS

Each project reveals more of the secrets of brush calligraphy, so that by the end of the book you will be armed with everything you need to continue on your own lettering adventure.

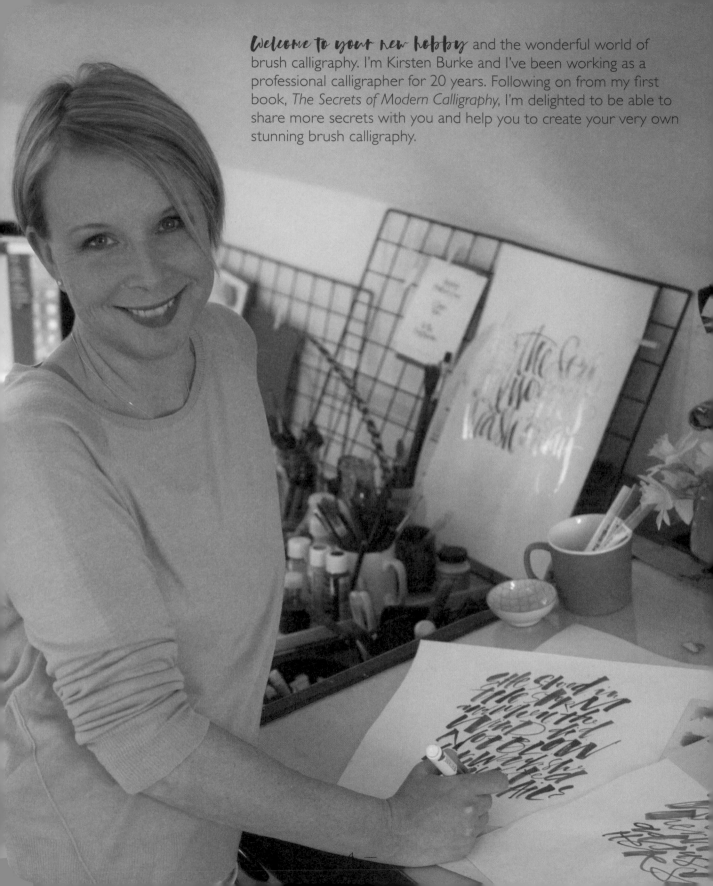

Welcome to your new hobby and the wonderful world of brush calligraphy. I'm Kirsten Burke and I've been working as a professional calligrapher for 20 years. Following on from my first book, *The Secrets of Modern Calligraphy*, I'm delighted to be able to share more secrets with you and help you to create your very own stunning brush calligraphy.

Calligraphy is an escape!

You forget about everything around you as you become completely absorbed in your lettering. In this book, I'll show you how to use the different tools available, from the latest must-have calligraphy tool, the brush pen, to water brushes and lastly real paintbrushes. There are seven projects for you to complete and as you work through them, your calligraphy will improve. You'll learn a few techniques like 'blending' (mixing colors together) and 'bounce' (how to make your letters dance around the page). The effects can be amazing!

Why use a brush?

Lettering with brush pens is a fun way to create calligraphy and with some simple instructions, I'm going to show you how easy it can be. Brush pens give greater line variations (thick and thins) and allow you to create larger lettering than you can with a calligraphy nib. One of the best things about brush pens is that you can take them anywhere and there's no ink or mess!

I want you to enjoy brush calligraphy right from the start, so instead of drills (where you go over the same letter again and again), I've created projects with simple templates for you to copy using some of my favorite phrases. Both techniques teach you the same muscle memory, but templates give you a reward to inspire you to keep going! I will be throwing in tips and tricks along the way, so that when you've finished the projects you will know the secrets of brush calligraphy. Lastly, at the back of the book, I've copied the phrases onto separate art cards for you to pull out, complete and treasure.

What makes it modern?

Brush lettering has its roots in the Far East, where it has been an integral part of the culture for centuries. This is why Japan is still the main supplier of brush pens.

Modern calligraphy is about lettering that has energy and flow, and brush lettering allows you to be the most creative of the calligraphy arts. You can choose to go slowly and deliberately or fast and frantically to get different effects. Brush lettering involves the pressure and release of the brush so that you get thick and thin lines; think of it more as drawing than handwriting. You can lift your brush or brush pen off the page whenever you feel you need to assess what you are doing, consider the shape of the letterform and ponder what to do next.

Traditional calligraphy focuses on the structure of the lettering and is concerned with making every single letter the same. We will explore the rules so that you understand them and know how to apply them, but as modern lettering is about creating unique and intentionally irregular letterforms, we'll also explore playing with those rules.

Although more casual than most forms of calligraphy, brush lettering still takes some patience and practice to learn. Like most skills, it doesn't just happen overnight, but in this book we will have lots of fun along the way. Brush lettering is the fun-loving, free-spirited rebel of the calligraphy gang.

So let's begin!

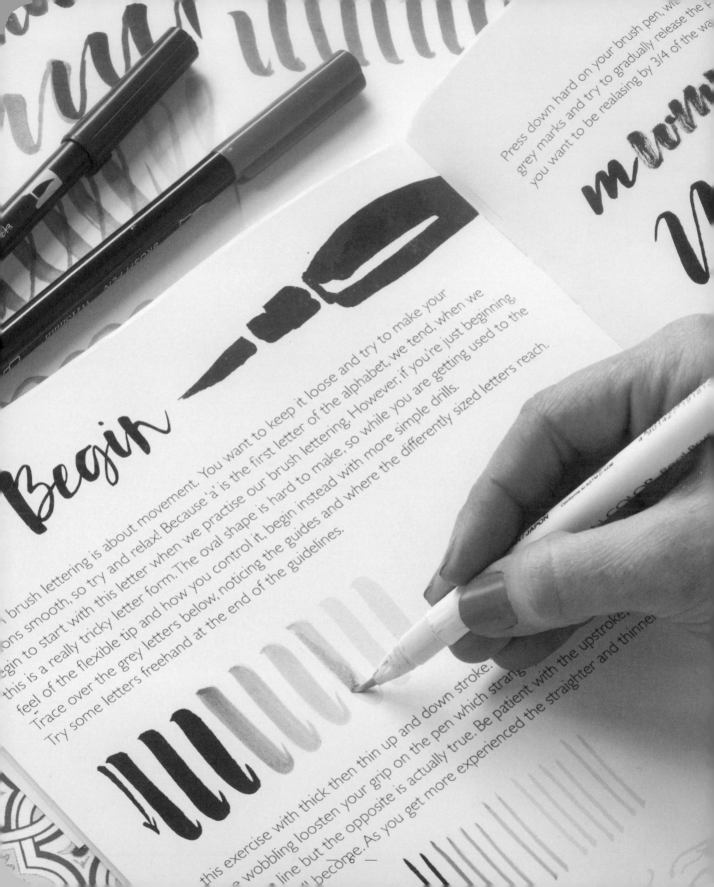

Begin

...n brush lettering is about movement. You want to keep it loose and try to make your ...ons smooth, so try and relax! Because 'a' is the first letter of the alphabet, we tend, when we ...egin to start with this letter when we practise our brush lettering. However, if you're just beginning ...this is a really tricky letter form. The oval shape is hard to make, so while you are getting used to the ...feel of the flexible tip and how you control it, begin instead with more simple drills. ...Trace over the grey letters below, noticing the guides and where the differently sized letters reach. ...Try some letters freehand at the end of the guidelines.

...6 —

...this exercise with thick then thin up and down stroke. ...e wobbling loosten your grip on the pen which strang ...e line but the opposite is actually true. Be patient with the upstroke, ...!! become. As you get more experienced the straighter and thinner

Press down hard on your brush pen, w... grey marks and try to gradually release the p... you want to be realasing by 3/4 of the wa...

How to Use this Book

Work straight into the book

I know you don't want to spoil it, but this book has been designed for this purpose. It also means that you can follow your progress. When you have finished this book, look back at the first few pages and you'll be amazed at how much your calligraphy has improved.

1

Projects

This book contains seven projects to work your way through, starting with the basic principles of hand lettering and gradually teaching you different techniques, allowing you to have the confidence to start to develop your own style. You will gain a real understanding of letterforms, so that by the end of the book you will be on your way to mastering this rewarding and absorbing skill.

2

Tips and Tricks

Look out for my 'secrets' and also the light bulb symbols at the bottom of some pages. These give you my insider tips and tricks to help you as you practise. Discover what materials you should buy to get the results you want, so that you can be sure you're spending your money on the product that's right for you.

3

Templates

These are my secret weapon! Instead of writing single letters out again and again, it's much more fun to work over my templates (faint calligraphy). You learn all the same skills and gain the muscle memory you need in order to go it alone. Each template has a matching art card at the back of the book – a fantastic reward to inspire you to keep going!

Watch

Access **Kirsten Burke Calligraphy** video tutorials on my YouTube channel, where you can watch me as I demonstrate the skills I've been teaching – it's just like coming along to one of my workshops! Whenever you see the symbol above, scan the QR code with your phone or tablet. You'll need a QR code reader app, which is free to download.

Bic Marker Posca
Tom Bow Mozart
Kuretake Galt
METALLIC
Ecoline Paint Brush
Pentel Zig
Koi
Pentel Colorbrush
Touch Sign Pitt
KB Sailor Waterbrush
Sakura Pigma Paint Brush

Felt Fibre

337 Brush Pen
ECOLINE
PTT artist pen
touch サインペン
SAILOR
Koi Coloring Brush Pen
Tombow ABT 725
BRUSH PEN
Papermono
Fluid Metallic Brush Markers
BIC Marking
Mr. Brush Pen
BLACK
CLEAN COLOR Real Brush

Brush Lettering Tools Decoded

Secret 1

The beauty of brush lettering is that it can be as simple or as complicated as you choose. You can produce beautiful work using just one brush pen, or you can experiment with a variety of techniques, colors and products, and also combine them to give an assortment of different effects. Once you know how the products all work, you'll be able to mix and match them to your heart's content!

What Shall I Use?

In this section I'm going to talk about some of the brush lettering products available, although this is constantly changing and growing as calligraphy becomes more and more popular. Then we'll look at the different ways in which you can use them.

Types of Brush Pen

The difference between brush pens and felt-tip marker pens is that brush pens have a brush-like, flexible tip that behaves in a similar way to a paintbrush. When you apply pressure to the paper with a brush pen, you can either get a thick or thin line. This is the difference between calligraphy and handwriting. The elasticity of the brush pen separates the good from the bad. The tip should spring back into shape as if it's never been used before. The end should keep to a point and not fray or bend out of shape after it's been used a couple of times. There are two main types to choose from: felt-tip brush pens or fibre tip (sometimes called bristle tip) brush pens.

Felt-tip Brush Pens

Felt-tip brush pens are less flexible than fibre tip brush pens, so they're often preferred by beginners as they are easier to control. You get more predictable marks and they hold their point more consistently than a hairy bristle/fibre tip brush pen, but they are more likely to fray with use.

Felt

Fibre Tip (Bristle Tip) Brush Pens

Fibre tip brush pens mimic the behavior of a natural paintbrush. They either have synthetic nylon or natural hair bristles and these bristles splay out when you press down, so they're much more flexible to use. As the end is 'floppy' they can take time to get used to, but they give brushy effects with more contrast between thick and thins than a felt-tip brush pen.

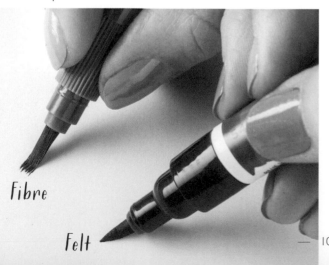

Fibre

Felt

Fibre

Different Sizes

The majority of brush pens on the market are quite large so produce thick downstrokes, meaning that you will be creating quite large lettering, much larger than if you were using a nib. If you are writing names on invitations or place cards you will need a small brush pen, which gives letters similar in size to a pointed nib (see the photo below).

You can't assume just from looking at the tip how thick the downstokes might be, so it's particularly important when buying brush pens that you test them out. A small but soft tip will often produce a thicker stroke than a bigger-looking hard tip.

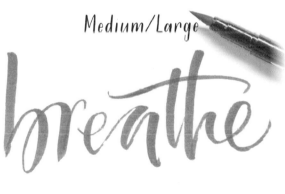

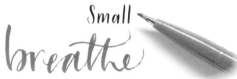

Dual-tip

A dual-tip brush pen is quite simply one that has two ends! In the US at the moment, most dual-tip brush pens have a brush tip one end and a bullet tip the other. I've always found this a little weird, as I think it's more useful for a 'dual' brush pen to have two brush ends – one small and one large, so that you get two for the price of one. After years of waiting, there are now a couple of brands, 'Sailor' and 'Uni' that have made a dual tip brush pen that has a fine tip one end and a medium tip the other – happy days!

Water-based or Permanent Colors

By now your head may be spinning a little, but there's one more thing that you need to know. All these different types of pens will either have water-based or permanent ink.

Water-based pens are fantastic, as you can blend from one color into another. This means that if you have a red pen you can dip it into a blue ink and you will get purple (remember your primary and secondary colors from school). When you've finished, you can wash it in water to get it back to its original color.

I'll explain more about blending later on in the book in Project 4. With water-based pens, if you get drops of water on your project, the ink will run, so bear this in mind if you are using them for place cards that may get water splashes on them!

Permanent ink does what it says on the tin – it is permanent, so it will not run, but it also won't blend and if you get it on your clothes it will not come out.

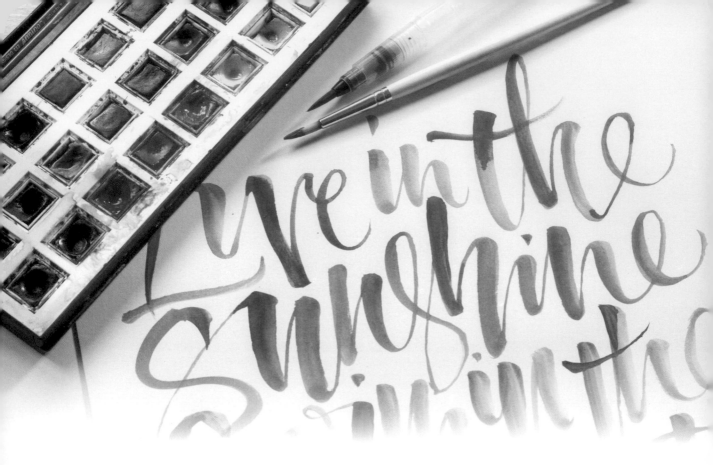

Water Brushes

A water brush not only has a flexible tip like a fibre tip brush pen or a paintbrush, but it also has a refillable liquid cartridge. You can choose to fill this with either water or ink. If you fill it with water, you can dip into various inks or paints and then use it in the same way as a paintbrush. If you dip into a color and then squeeze the cartridge as you go, you will get a more watered-down version of the color you're using. This can be a lovely effect, especially when doing washes.

If you fill it with ink, you can keep working until the ink runs out without the need for any dipping. You may want to get a few water brushes though, as it can be hard to get the color out of them.

Paintbrushes

Working with a real brush can seem a little daunting, but once you get used to how to control it, the range of styles and effects that you can create is endless. It is perfect for expressive styles that are free and energetic.

There are lots of sizes, starting with 0000 as the smallest and up to 30 as the biggest. It doesn't matter if it's synthetic or sable as long as it has a rounded, pointed tip.

To create lettering similar in size to the examples in this book, you will need a pointed, round paintbrush either size no. 2 or no. 3. For smaller lettering a size 00 is similar to the small end of the Sailor brush pen, or the Pentel Fude Touch Sign pen, and is perfect for place cards.

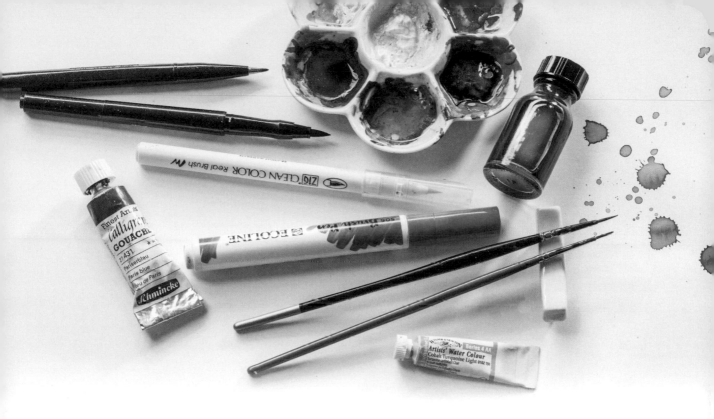

My Favorite Brush Pens

Sailor Pen
This pen has two brush tips – one small, one large, so it can handle any size lettering. It gives a very satisfying solid black. Many brush pens don't have such a rich tone. The ink is permanent, so the small tip is perfect for invitations or place cards as it won't run.

Pentel Fude Touch Sign Pen
This brush pen has a crisp feel and is easy to control. If you like working small it's a great tool, plus it comes in many vivid colors. It is water-based, so can be used for color blending.

Ecoline Brush Pens
Their thicker barrel can feel a little strange to hold, but the colors are bright and they blend well. They also have reversible tips, so when one end starts to wear out you can pull it out and turn it around, doubling its life.

Zig Clean Color
If you prefer a fibre tip as I do, this pen has stunning colors and gives crisp, clean lines. It's smaller than the Ecoline and the work you produce will therefore be much more delicate.

Paintbrush
I always return to using this. You can dip into paints, inks, metallics – anything. It takes a little getting used to as it's so flexible, but ultimately this is what makes it the best tool. Nothing beats the real thing once you've had a little practice.

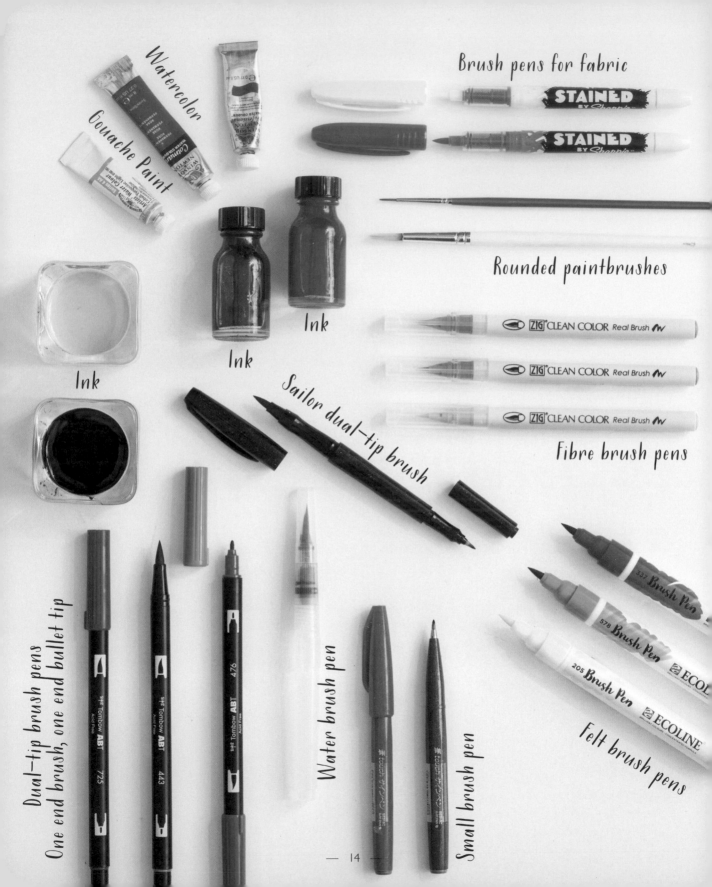

Watercolor

Gouache Paint

Brush pens for fabric

STAINED BY Sharpie

STAINED BY Sharpie

Rounded paintbrushes

ZIG CLEAN COLOR Real Brush

ZIG CLEAN COLOR Real Brush

ZIG CLEAN COLOR Real Brush

Fibre brush pens

Ink

Ink

Ink

Ink

Sailor dual-tip brush

Felt brush pens

337 Brush Pen

578 Brush Pen ECOL

205 Brush Pen ECOLINE

Dual-tip brush pens
One end brush, one end bullet tip

Tombow ABT 725

Tombow ABT 443

Tombow ABT 476

Water brush pen

Small brush pen

— 14 —

Materials

Ink and Paint

You can dip your brush pen, water brush or paintbrush into any water-based ink or paint to get blended colors then simply wash it in water to clean it and return it to its original color. There are all sorts of unusual inks appearing in shades like neon or with semi-transparent properties, but paint still offers the greatest choice. With brush lettering you can buy ready-mixed tubes of gouache and easily mix your perfect color in a palette.

If you are working onto other surfaces (especially anything that might get wet or is shiny), acrylic paints are best as they dry to a permanent 'plasticy' consistency. You can also buy paints designed for specific types of surfaces, i.e. fabric and metal.

If you are creating artworks for your wall, make sure that regardless of the ink or paint you choose, it is lightfast, so resists fading in a room filled with light! Look out for descriptions that include archival or lightfast ink.

Paper

You can't work on just any type of paper as the ink can feather or bleed, which makes even the most stunning lettering look scruffy. Ideally you need a smooth paper like a 'Rhodia' pad, as most normal copy paper will shorten the life of your brush pens. You have a choice of plain, lined, angled or dotted guides to help keep your letterforms consistent. If you are using a water brush, watercolor paper is best.

Next year, I will also be bringing out a *Secrets of Brush Calligraphy Practice Pad*, which will have more tips & tricks and alphabets in it, so keep an eye out for it in the shops!

However, as you are a beginner, a good quality laser paper from most retailers should work well enough for you to get started with and won't break the bank. As your skills develop, you can move over onto more expensive art boards.

Layout Paper

I would recommend buying a pad of layout paper. This is a semi-transparent paper that's great for tracing with. You can't use tracing paper as it's shiny, so ink and paint isn't absorbed and will smudge. It's available from most high street and online shops, meaning that you can go over both the lessons in this book as well as my projects and templates again and again, so that you get plenty of practice.

Metallics

There are a large variety of different metallic paints, pens and inks available to add a bit of sparkle to your work. I'll talk more about these on page 89. You can use them on their own or dip into them to turn your colors metallic.

On a Budget

There are loads of amazing products that you can mix and match on the market, but all you really need is a black brush pen. I'd recommend the Sailor dual-tip brush pen (felt) for your black pen and, if you want to add a bit of color, the Tombow set of 10 dual-tipped brush pens (felt) are a great choice.

The only other things you need are a pencil and rubber for sketching out your ideas.

Starter Kit

I've put together an 'Essential' brush calligraphy kit, which has everything you need to get started: a black Sailor brush pen, a water brush with two colored inks to dip into for blending and a paintbrush. Once you've mastered the brush pen, you can move on to the water brush and lastly the real paintbrush.

Once you've tried the different tools out you will be able to compare them. Look at the different effects that you get from each one and decide which is best for the various lettering projects that you want to do.

Position

How to Hold a Brush Pen

Hold the pen gently. It needs to feel comfortable and not hurt, so experiment with different grips until you find one that suits you and allows you to apply differing amounts of pressure.

For the downstroke, you need to hold your pen at an angle of 35 degrees to the paper and tilt the pen over onto its side. Put pressure on the tip by pressing down, so that you use the whole of the side of the brush to get those big, fat downstrokes. For the upstroke, you need to rise up onto the end of the tip and go lightly to make a delicate, thin upstroke.

As you practice, the pressure changes will become more natural and you will start to get greater contrast between your thick and thin strokes.

Paper Position

With brush calligraphy you can play around with the position of the paper, so that you get both the letter shape and thick and thins that you want. Using the entire movement of your arm from your shoulder, rather than just your fingers and wrist, allows you to flow more naturally from one letter to the other.

Left-handers

It doesn't matter at all if you are a left-hander, as all brush lettering tools work equally well for lefties and righties!

If you are a left-hander, you will probably be familiar with smudging, as the Latin alphabet we write is from left to right, so you will need to experiment with both your paper position and pen strokes to find what works for you to avoid this.

The big advantage of these tools over the nib for lefties is that you can go up or down with a brush pen equally well. So, whether you are an 'over-writer' or 'under-writer', as long as you tilt the pen and work on the side of the tip for the thick strokes and use the very tip for the thin strokes, you can start at the top or bottom of the letter – whichever feels more comfortable for you.

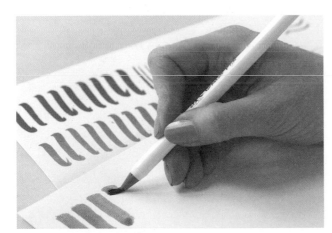

**Downstroke position
and angle to hold your pen**

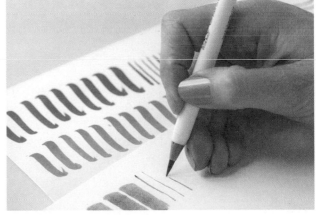

**Upstroke position
and angle to hold your pen**

Getting Started

Secret 2

It's all about the downstroke.
Focus on those thicks! Make them as thick as you can.
It's the contrast between your thick and thin lines
that transforms normal lettering into calligraphy.
If you do this, no matter what your style is, your
lettering will be transformed.

Let's Begin

Brush lettering is all about movement. Relax and try to make your motions smooth! Each letter is just a selection of shapes. As 'a' is the first letter of the alphabet, you may think it's a good letter to start practising with, but if you're a beginner, 'a' is quite tricky. The oval shape is hard to make, so while you are getting used to the feel of the flexible brush tip and how you control it, instead begin with more simple drills.

Trace over the thick gray lines below and try to make your mark a similar thickness to mine. Press down on your brush pen with it tilted to the side slightly to get a thick downstroke.

Downstroke

Next, go over the thin gray marks below and try to use the very tip of the pen as you go up. Use the lightest touch to get your line as thin as these.

Cross stroke

Upstroke

Tip
Adjust the angle of your pen and your paper until you find the position that works best for you to create these thick and thin strokes.

Now do the ups and downs together. Push hard when you go down to get nice fat strokes and be delicate when you go up to make thin strokes.

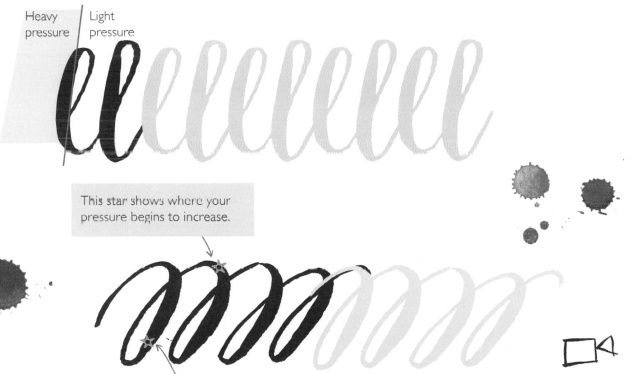

The change of pressure you apply to the brush to get a thicker or thinner line is called the transition.

Once you have got to grips with the up- and downstrokes, you are ready to master more challenging shapes, like curves.

As you start the downward stroke, gradually increase the pressure so that your line gets thicker. Then, before you get to the bottom of the stroke, release a little pressure. This way, your line will be thinning out, ready to change to a thin upward stroke. This is called the transition.

Heavy pressure | Light pressure

This star shows where your pressure begins to increase.

This star shows where your pressure starts to decrease.

YouTube
Kirsten Burke Calligraphy
Brush Secrets – Brush Pen Pressure

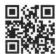

Curves

The type of brush pen you use will give you very different results. Remember, felt brush tips are less flexible, more like felt-tip pens, so give predictable strokes! Real paintbrushes, water brushes and fibre tip brush pens behave similarly and are much more responsive, so are often preferred once you have got a bit of experience under your belt. Below I have drawn the shapes first with a felt brush pen (Sailor) and then with a fibre brush pen (ZIG Clean Color).

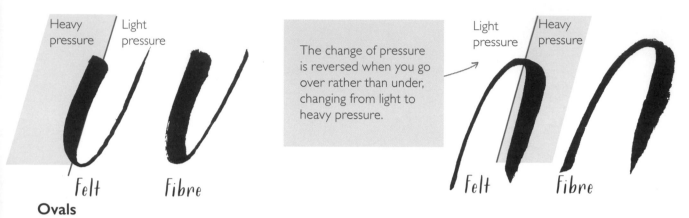

The change of pressure is reversed when you go over rather than under, changing from light to heavy pressure.

Ovals

It's important to have the thick stroke (the weight of the letter) to one side. Everything on the other side is light. By drawing a line down the middle of an oval, you can clearly see that the two sides have a contrasting thickness.

This line shows you that the thick downstroke is to the left of the line. The thin upstroke where you use the tip of the pen is to the right.

When you work with a water/paintbrush, or a fibre tipped brush pen, the contrast of the thick and thin line is far more obvious. But the rules still apply, even though the lines look different.

You don't want your thick stroke to drop to the bottom of your letter. By beginning to lift the pen off the page before you get to the bottom, you will avoid having saggy bottoms!

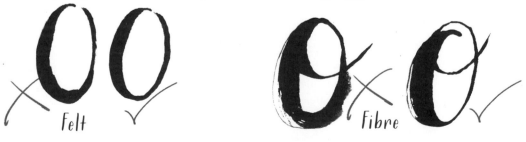

Practice Makes Perfect

Try going over the gray shapes below, then try a few freehand.

vu uu uuuuu

vu uu uuuu

nnn nnnn

oo oooooo

oo oooooooooooo

To make the thin upstroke, lift the pad of your hand up off the surface slightly and use your fingertips to steady yourself as you bring the pen to its tip.

Shapes into Letters

The change of pressure to move from a thick to a thin line is the same throughout the alphabet. An important rule to understand is that all individual letter strokes move up and down between two guidelines – the baseline and the waistline.

The baseline is the line at the bottom that you write along and the waistline is the line where the top of the letter sits. Look at the shapes that make up the lower-case 'a'. Placing an oval next to a downstroke creates an 'a'.

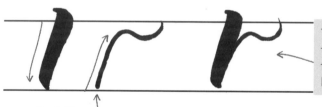

Waistline

This up and down motion will help give you rhythm as you work, which will make your lettering flow.

Baseline

Now look at the 'r'. The thin line of the 'r' starts at the baseline and travels over the downstroke already there.

Waistline

These two shapes are then joined close together to create the lower-case letter 'r'.

Baseline

From the baseline, you go upwards with a light pressure. You don't see the start of this stroke once the letter is joined together.

Capital letters reach above the waistline, so their strokes are longer. The two shapes below, positioned closely together, create the letter 'R'.

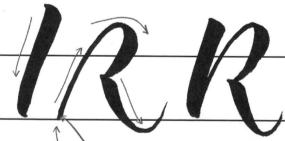

From the baseline, you go upwards with a light pressure, as you start to make the over turn you 'transition', gradually increasing the pressure, then releasing again to return to a thinner line.

By breaking it down you can see that the upstroke starts lower, at the baseline and goes back over the downstroke that is already there.

Practice Makes Perfect

Try going over the gray shapes below, then try a few freehand.

α a a a a a a a

o l q q q q q q

l o p p p p p p

ı r r r r r r

I R R R R R

When you see the letters broken down like this, it is easy to see that the alphabet is simply made up of shapes.

Alphabets

Secret 3

It's all about practice. Grab a little 'me' time to practice the strokes. Unlike when you learned joined-up writing at school, with calligraphy you can take your pen off the page as often as you need to and ponder your next stroke.

Don't worry if your upstrokes are a little wobbly when you start. Be patient. With more practice, the more natural it becomes.

Increase the Pressure

Downstrokes

Well, here it is, your first alphabet! I have separated the thick and thin lines to make it really clear how each letter is constructed. See those big, fat downstrokes and those curly, thin upstrokes? It's that contrast of thickness that makes brush calligraphy look so lovely.

With the downstrokes showing in bold, you can see clearly that the thick lines are the backbone of the letter structure.

abcdefgh
ijklmnopq
rstuvwxyz

The rules are the same for the upper and lower case letters of the alphabet. They are made in the same way, with thick downstrokes, thin upstrokes and thin cross strokes.

Downstrokes that go at an angle, rather than straight down, need to have less pressure applied, so that they are very slightly thinner than the other downstrokes. I've pointed them out below with arrows.

ABCDE FG

HIJKLM

NOPQRST

UVWXYZ

Release the Pressure

Upstrokes and Cross Strokes

The upstrokes are shown here in bold. Notice how fine they are in comparison to the downstrokes. I've included the cross strokes here too, as they aren't as thick as a downstroke. The weight of the cross strokes can vary depending on how you choose to style your lettering.

> Although I have joined the lower case letters together, remember that you can lift the pen from the page whenever you need to, pause, assess the shape you are making and decide where you are going next.

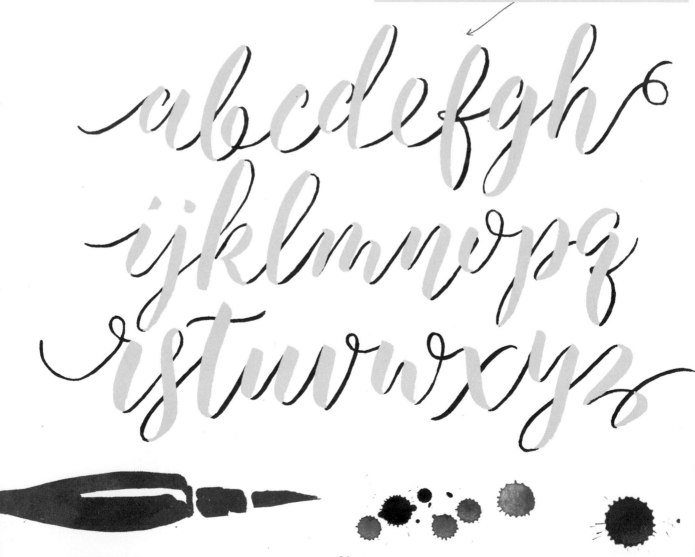

Be patient with your upstrokes –
the more you practice, the easier,
straighter and thinner they
will become.

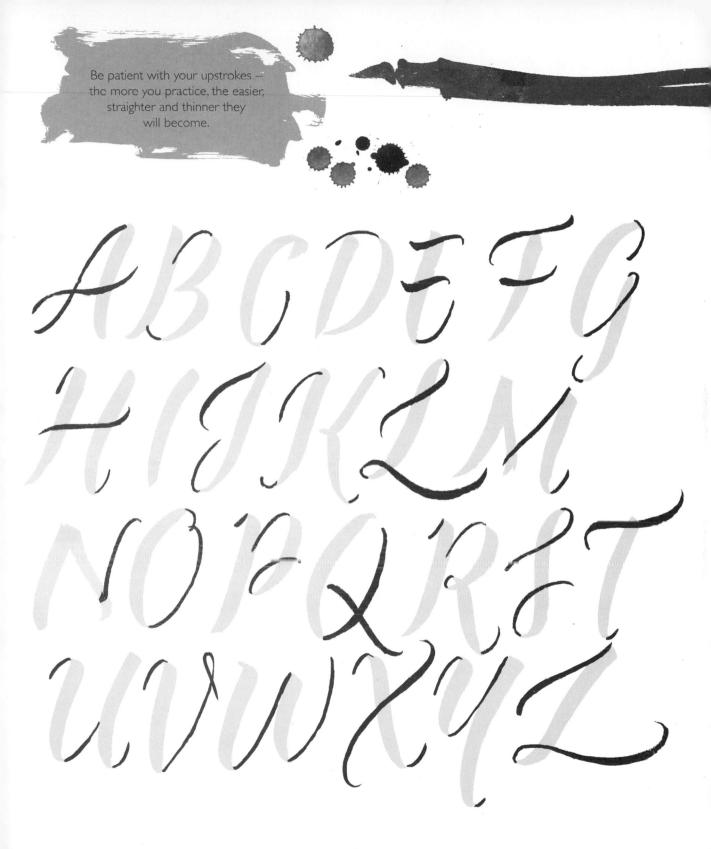

Stroke Order

Stroke Order – Capitals

So now it's your turn. Follow the arrows below to see the order of the strokes and their direction. The thick strokes are downstrokes and the thin strokes are upstrokes. Most cross strokes are thin, but I like a thick cross stroke for the 'L' and the 'T', so I adjust the angle of my page, to make those cross strokes thick.

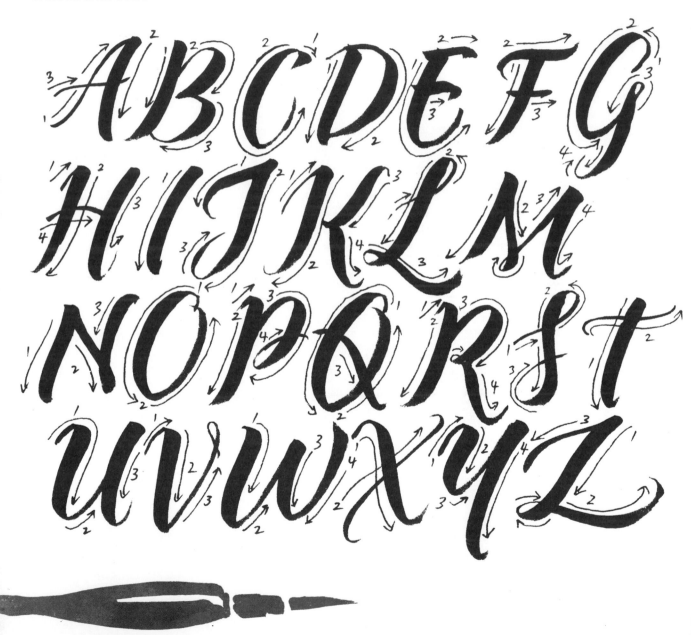

Write straight into this book, tracing over the grey letters and following the order of the numbers on the opposite page. When you look back at the end of this book, you will see how far you have progressed! Press hard when going down with your brush tipped to the side, so that the flat side of the brush is making contact with the paper.

A B C D E F G
H I J K L M
N O P Q R S T
U V W X Y Z

Tip
To get more practice, place layout paper over this alphabet and trace it as many times as you like.

Stroke Order – Lower Case

So now on to the smaller letters. These are easier as the strokes are shorter. Enjoy getting the feel of the pen and follow the arrows, but don't feel that you've done it wrong if you make the strokes in a different order. It is getting the thick and thins in the right place that is important.

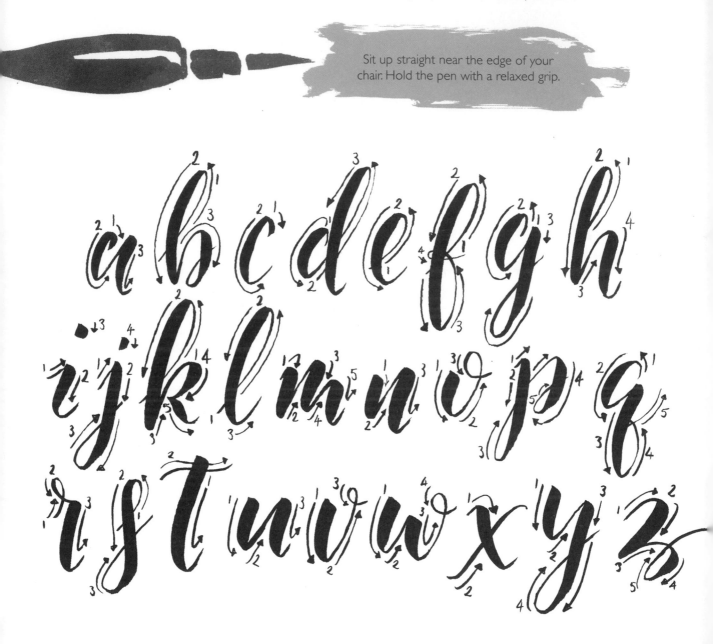

Sit up straight near the edge of your chair. Hold the pen with a relaxed grip.

Tip

If you find your lines are wobbly, loosen your grip on the pen. You may grip tightly to try to control the line, but the more relaxed you hold your pen, the smoother your lettering will be.

When you are going up, bring the brush/pen more upright, so that the tip can make a thin line for you. Keeping it light on the tip will prolong the life of your pen, too.

Are you holding your breath?
We often do when we are concentrating.
Try and remember to relax, take deep
breaths and keep your shoulders loose.

abcdefgh

ijklmnopq

rstuvwxyz

Alphabet

A B C D E F G
H I J K L M N
O P Q R S T U
V W X Y Z

abcdefghij

klmnopq

rstuvwxyz

1234567890

Alphabet

Created using a medium fibre brush pen.

ABCDEFG

HIJKLMN

OPQRSTU

VWXYZ

abcdefghij
klmnopq
rstuvwxyz
1234567890

Alphabets

Both created using a small felt brush pen.

A B C D E F G H I J

K L M N O P Q R

S T U V W X Y Z

a b c d e f

g h i j k l m

n o p q r s

t u v w x y z

& 1 2 3 4 5 6 7 8 9 0

ABCDEFG
HIJKLM
NOPQRST
UVWXYZ
abcdefghi
jklmnopqr
stuvwxyz
1234567890

Believe
you can,
and you're

Relax
nothing
IS IN
Control

Letter Shapes

Secret 4

Think of brush calligraphy as drawing,
not handwriting. You need to draw the letters twice
as slowly as you would if you were writing.
Brush letters require a consistent shape and an
understanding of structure, even with the most
expressive styles. It's not supposed to be perfect,
so relax with it and have some fun!

Believe you can and you're halfway there

THEODORE ROOSEVELT

Project 1

Skills:
Body shape
Alphabet families

Every alphabet has a 'family style' and the letters within it all have a relationship. The 'o' shape governs this relationship. Its shape may be fat and round, or narrow and tilted, but whatever shape you choose, it should be passed on to the other letters. When you look at the alphabet below, you can see how the rounded parts of an 'a', 'g' and 'p' all follow the 'o's lead, so have the same body shape. The proportion of the 'o' will also dictate the width of the other letters, even if they don't have an oval shape within them. See where I have placed the 'o' shape over the 'h', 'k', 'y' and 's'? These letters still have a consistent shape carried over from the 'o' and that is what's called their 'family style'.

In traditional calligraphy, the geometry of the Roman alphabet is applied, with letters fitting into a grid like the one below. Because modern lettering is more relaxed, those rules are simplified. This circle within a square is the foundation of the alphabet and can be played with when you form your letters, but understanding it will improve your lettering style.

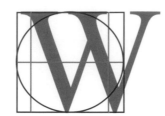

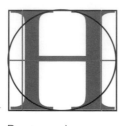

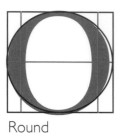

Round
CDGOQ

Rectangular
AHNTUVZ

Wide
MW

Narrow
BEFLPRS

Roman capitals have very strict proportions and having some awareness of them will help with your calligraphy. They all fit into a grid like this one.

Miscellaneous
IJKXY

So let's look at how this grid influences more casual letter styles created with a brush. Can you see how the letters from this alphabet fit into the grid below? The rounded letters follow the circle, which I have tilted, but still fit within the square. The square helps to keep the letters all looking like they belong together by giving them their width and height.

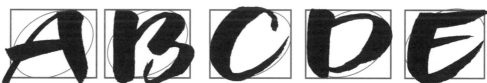

Have a go yourself. Try writing into these shapes to create some letters with your brush pen.

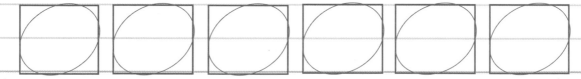

YouTube
Kirsten Burke Calligraphy
Brush Secrets – Body shape

If I change the shape of the square by squashing it into a rectangle, the proportions of the oval inside it and therefore the letter's shape change again. For this style, the rectangle is tipped forwards and it's narrower than the square, so the letters follow this shape, which keeps them unified.

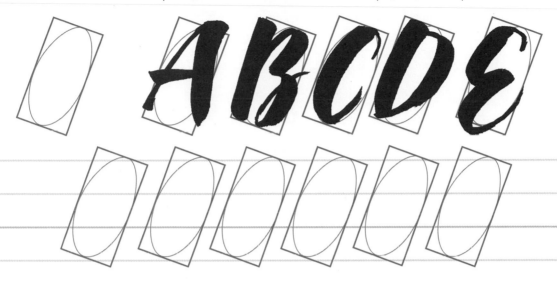

Have a look at the alphabet below, noticing how the oval shapes are followed throughout.

With the lower-case letters, the rules still apply, although the height of the letters change because of the ascenders and descenders. If I draw that oval shape around the 'body' of the letters, you can see how they follow its width and size, with the exception of the wide and miscellaneous grouped letters.

abcdefgh

abcdefgh

Write your initials within the different 'o' shapes on the lines below. Notice how the letter's style changes depending on the 'o' shape you are following.

Think about the body shape for each project that you do. If you were designing a Halloween invitation, you might choose a narrow body shape for your alphabet. That would give a spiky and sinister look. Compare the styles below. Notice how the rounded lettering on the right of the page doesn't work nearly as well as the narrow style on the left for this theme.

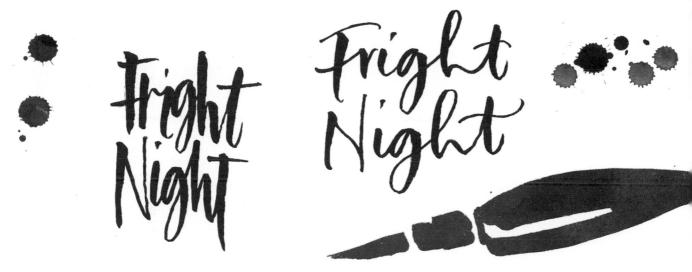

Change the context of your calligraphy to an invitation for a christening or naming day and you can see that a softer, rounded lettering style works much better than the narrow, spiky one.

Tip
The lettering style gives atmosphere to your piece. Even before you read it you can get a feeling of what it is about.

Writing a Quote

Designing pieces of calligraphy to decorate my home is my favorite thing to do. At the back of this book are seven art cards that I have designed specifically for you to pull out and put on your wall for inspiration, or to give to someone to brighten their day. Practice writing over the phrase below and then, when you feel ready, you can rework it straight onto the matching pull-out card (Art Card 1) at the back of this book.

Believe
you can
and you're
halfway
there

Once you have traced the words, try writing them again on this page on your own, using only the guidelines below. If you are worried about writing freehand, you can always sketch the words out gently in pencil first, then trace over them with your brush pen. Remember, your connecting strokes need a delicate touch.

Tip

Using the entire movement of your arm, rather than just your fingers and wrist, will allow you to flow smoothly from one letter to the other.

Art Card 1

Go over the gray lettering below, then try doing it again on the pull-out art card at the back.

Believe
you can
and you're
halfway
there

THEODORE ROOSEVELT

Styles & Sizes

Secret 5

Brush letters can change shape and size, even in the same word, depending on the composition of the piece you are creating. The shape of the same letter can be altered by the other letters around it and the space you want it to fill. You might decide to stretch one 'a' and then 'squeeze' another to create balance within a word or in your piece as a whole.

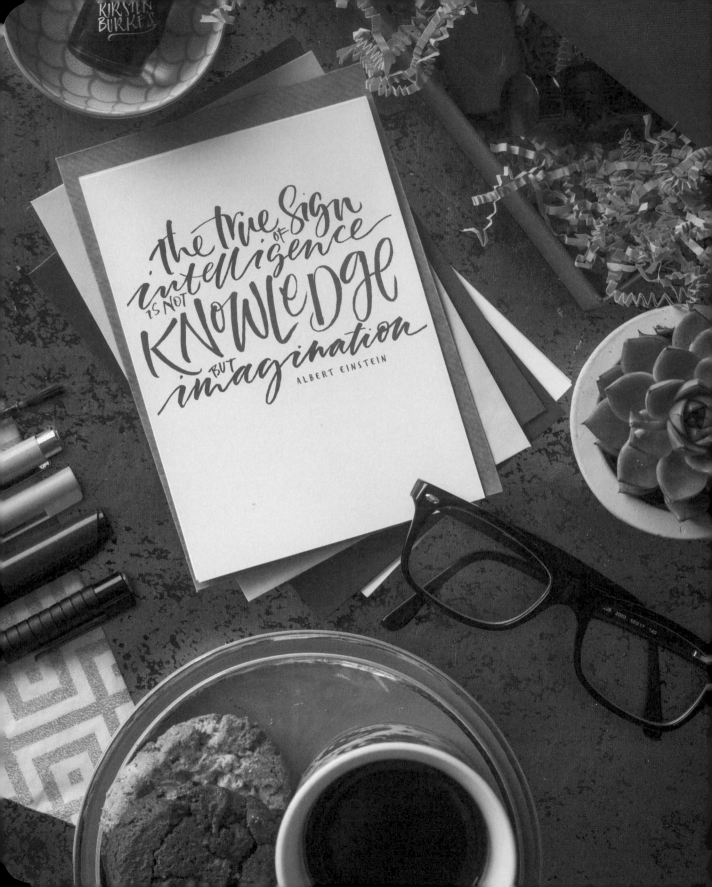

Project 2

Skills:
Proportion and spacing
Connecting letters

This project experiments with changing the size and proportions of your calligraphy. If you have a small brush pen, or a dual-tipped brush pen, you can use the small end here. If not, just go very lightly with your medium/larger brush pen to make this smaller lettering.

The 'X' height is the height of your lower-case letters. Below, I have used an 8mm 'X' height and written first with a medium pen, then kept the same 'X' height but written with a smaller pen. You can see how much thinner and finer the lettering is in the second example. It may sound obvious, but if you are going to be doing lots of smaller writing, use a small brush pen instead of struggling trying to create really fine lettering with a tool that is too chunky.

Ascender

Waistline

Medium brush pen *imagination* Baseline X height 8mm

Descender

Small brush pen *imagination* X height 8mm

By increasing the 'X' height and using a medium brush pen, the lettering has to stretch higher to reach the waistline. By changing the proportions of the letters, the whole 'look' of your lettering alters. This is something you can play around with by using different-sized brushes and brush pens.

Medium brush pen *imagination* X height 16mm

Connecting Letters

When joining your letters to each other to make words, you always use a thin stroke. Trace this alphabet, going as lightly as you can as you join the letters together, so that you get the thinnest line possible between the letters. Break your letters down into strokes, remembering you can lift whenever you need to, so you can consider the next shape that you're making. This helps with legibility. Thin joining strokes help the letters stand out, so the reader can easily see the letters. If you want to add flicks and flourishes to your lettering, keep them thinner than the main letterform for the same reason. You want your work to be just as easy to read as it is to be admired.

The thin line at the end of a word is called the exit stroke.

The joining stroke at the beginning is called the entry stroke.

abcdefgh

ijklmnopq

rstuvwxyz

The joining stroke is nice and thin, which helps with legibility as well as looking good!

Tip

Go back over lines you're not happy with. You will be able to see where you've gone over a stroke as it will look darker, but don't worry, it gives the piece depth and is totally acceptable! Redraw the whole stroke and that way you won't draw attention to a bit that was wobbly.

Another fun way to add style and variation is to stretch the spacing between your letters, creating elongated connecting strokes. Decide on the size of gap you want to leave and then keep that space equal between each letter. As you've increased the space between each letter, you must also increase the gap between each word, to make it clear when one word ends and another begins.

intelligence

knowledge

Stretch out your letters by extending the entrance and exit stroke of each letter. This creates a style that is calming, like the waves of the ocean.

imagination

Try going over the top of the gray words here, keeping the connecting strokes thin.

intelligence

knowledge

imagination

YouTube
Kirsten Burke Calligraphy
Brush Secrets — Proportions

Proportion & Spacing

ABCDEFGHIJKLMN
OPQRSTUVWXYZ

Written in a medium-sized brush pen, with heavy pressure, the small caps look thick.

By reducing the size of the pen, I can reduce the thickness. This is written with a small brush pen.

ABCDEFGHIJKLMN
OPQRSTUVWXYZ

ABCDEFGHIJKLMN
OPQRSTUVWXYZ

Or I can push down less with the medium brush pen. This applies less ink to the page, giving similar lettering to the alphabet in orange above, which was created with a small brush pen.

The size and proportion of your lettering have a big impact on your overall design. You can mix proportions up in one piece of work to create what is called a 'hierachy' of importance. So think about which words you want to stand out; the 'hero' words.

Usually when we read a whole word in capitals it makes us think of shouting. It's a way of emphasising a word. In hand lettering this is still true, but only if you write big and in caps. Have a look at the examples on the next page.

If you use small capitals they can act as a kind of linking tool, but they must be much smaller than the rest of your lettering. You might write the word 'Bride' and 'Groom' in large, sweeping calligraphy, and then add the word 'and' in small caps, so that the most important words take centre stage.

Above is a simple alphabet, all written in capital letters with a brush pen. The letters in each example are the same width and height, but I wrote the top version with a medium brush pen (Sailor) and the second one with a small brush pen (Pental Touch), which is why my line is thinner on the second alphabet.

You can still use a medium/large brush pen for your incidental words, if you change the pressure you apply to your downstrokes. You can keep the lettering the same size, but go delicately to lighten the look of the letters, so that there is less ink on the page and more white space.

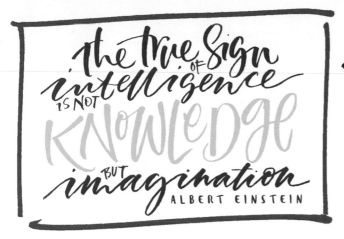

Another trick is to increase or reduce the space between each letter within a word. By squeezing the letters together, you create a denser look, as all your brushstrokes are close together.

If you spread them out you allow more white space around your brushstrokes. This makes those words seem less important, because the eye is drawn to where there is the most color. In the examples at the top of the page, I have spaced the author credit out to make it secondary to the quote itself.

Write the word 'knowledge' into the three boxes where it is missing. Change the size of your lettering, then the pressure you apply, and see which version you think is most successful.

Art Card 2

Go over the gray lettering below, then try doing it again on the pull-out art card at the back.

the true sign of
intelligence
is not
KNOWLEDGE
but imagination

ALBERT EINSTEIN

Words into Pictures

Secret 6

Don't rush! Go slowly and deliberately, and completely focus on the letter shapes you are making. That's what makes calligraphy so relaxing. You become completely absorbed in what you are doing, so the worries of the world wash away. Your eyes are learning to see subtle differences in your letter shapes and your hand is learning the muscle memory it needs to improve drawing each letter shape, too.

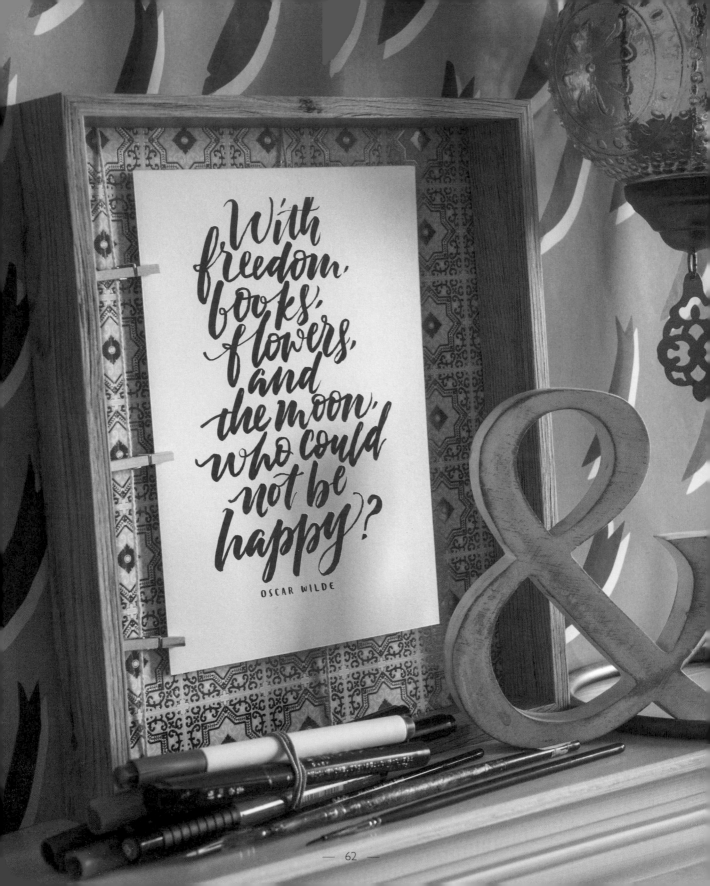

With
freedom,
books,
flowers,
and
the moon,
who could
not be
happy?

OSCAR WILDE

Project 3

Skills:
Angle
Bounce

Modern calligraphy plays around with the traditional rules, so you need to know the rules before you can adapt them to make your very own unique style. In traditional calligraphy every letter is identical and sits neatly on the baseline. Modern brush calligraphy gives letters a chance to show off and 'dance' around the guidelines. See how the word below uses the guidelines loosely? This is what gives modern lettering its contemporary style.

Don't abandon the rules altogether though, as they will help with consistency and improve the look of your lettering. You want your lettering to dance deliberately, not be messy.

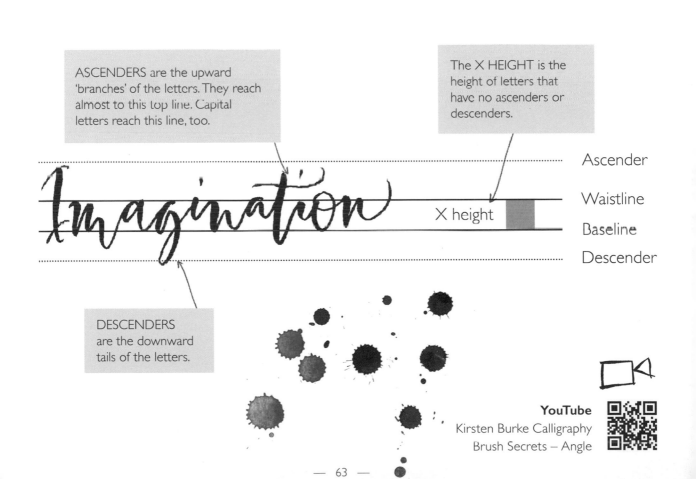

ASCENDERS are the upward 'branches' of the letters. They reach almost to this top line. Capital letters reach this line, too.

The X HEIGHT is the height of letters that have no ascenders or descenders.

DESCENDERS are the downward tails of the letters.

X height

Ascender

Waistline

Baseline

Descender

YouTube
Kirsten Burke Calligraphy
Brush Secrets — Angle

— 63 —

The Angle

Regardless of whether your letters sit up straight or lean, you need to aim for them to follow the same angle, keeping the downstrokes parallel throughout your piece of work. Have a go at writing over the words below and notice how on each line the angle steepens.

Can you see the way the thick downstrokes are all at the same angle? A consistent angle or tilt is what you are aiming for.

Freedom

Ascender

Waistline

Baseline

Descender

Freedom

Freedom

Neither upright nor slanted is right or wrong, it is simply a design choice.

Here's the same word with a steeper angle. This version is following the angle of the vertical lines on these guides.

Tip
Brush lettering is not joined-up handwriting; it involves pen lifts. There's a lot to consider, so go slowly and enjoy making your letterforms with a consistent, methodical movement.

Bounce Lettering

Give fun and energy to your calligraphy by 'bouncing' it. A simple way to do this is to make one or two letters big, then a couple small, then go big again. Rounded letters look good smaller or larger than normal and tall letters like 't' look great stretched below the baseline. Exaggerate downstrokes alternately upwards and then downwards.

When you see a double letter or the same letter in a word twice, reduce the size or swoop down with one.

Exaggerate upwards.

Swoop downwards.

Reduce or increase the size of rounded letters.

Ascender

Waistline

Baseline

Descender

Imagination *oo ll*

Bouncing *Bouncing*

Alternate *Alternate*

Alternate your ups and downs within each word, so that your lettering still has balance.

Have a go yourself by writing over the gray words above.

 Tip
The trick to using bounce is to keep an eye on the balance of the whole word.

Bouncing your lettering is a great way of bringing your compositions to life and injecting energy! By making the words dance up and down, you can tuck letters into each other. Compare the two versions of the phrase below. In the first example there are gaps between the different lines of words. This is called negative space. If you fill these spaces by 'bouncing' – lifting one letter and dropping another down – your calligraphy 'knits' together into a composition.

It's all about balance

It's all about balance

Here there is negative space, so by lifting the 'o' of 'about' up, I can knit the ascender of the 'l' into it underneath, so the whole word can tuck in more closely.

In this next project we are creating a design where each line tucks into the next. You can see how this moves the phrase from simply words written out beautifully to a stunning calligraphic composition.

With freedom, books, flowers, and the moon, who could not be happy?

With freedom, books, flowers, and the moon, who could not be happy?

YouTube
Kirsten Burke Calligraphy
Brush Secrets – Bounce

Try going over the words below. Notice how the words bounce along the guides.

With freedom, books,

flowers, and the moon,

who could not be happy?

Now try it freehand, pencilling it out first if you need to.

Art Card 3

Go over the gray lettering below, then try doing it again on the pull-out art card at the back.

With
freedom,
books,
flowers,
and
the moon,
who could
not be
happy?

OSCAR WILDE

Color Blending

Secret 7

You can dip any water-based brush pens straight
into another colored ink or paint, then simply
rinse them under a tap and they will clean off as good as
new. The color of the pen you are holding will blend/mix
with the color you've dipped into. It couldn't be easier. If the
tip frays, many brands have a tip that can be pulled out
and flipped around so that you get double the life, so check
before you throw it away. Color mixing is all part of the fun,
so don't be scared to give it a go.

Relax nothing is in Control
BUDDHA

Project 4

Skills:
Color blending
Composition

With water-based brush pens there are so many techniques to create gorgeous effects and blending colors together is my favorite. This technique is simple and eye-catching, so I'll show you two easy ways to do it.

1. First, you need a smooth plastic surface like a piece of acetate (an empty, clean crisp bag will work). Start by scribbling your darker color onto the plastic. Next, use a lighter-colored brush pen and rub its tip into the color on the plastic so it collects some of that color. Now when you write you'll see a mixture of both colors within your calligraphy. Try using a dark and light tone of the same color, then try contrasting colors like pink and blue.

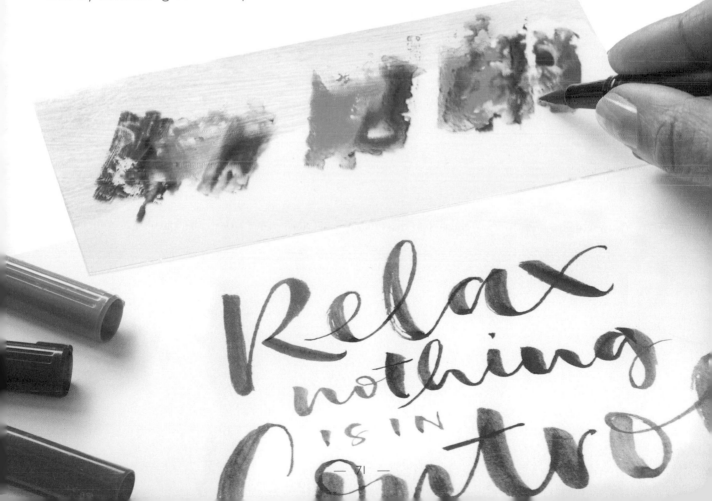

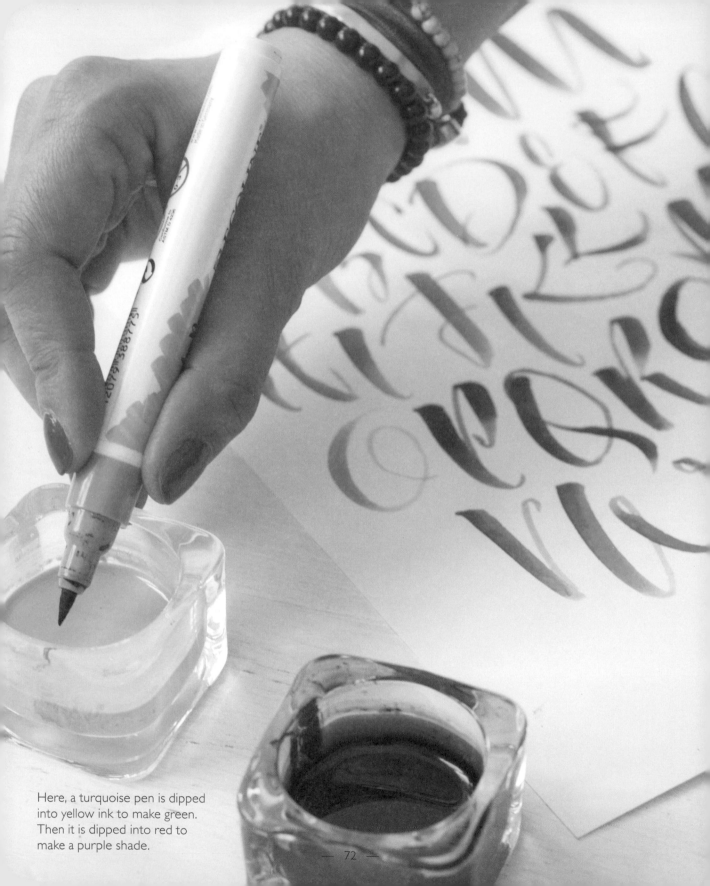

Here, a turquoise pen is dipped
into yellow ink to make green.
Then it is dipped into red to
make a purple shade.

2. Another way to color blend is to dip your water-based brush pen straight into colored ink. Ideally, use a smooth watercolor paper, as it will hold up better as you add layers of color. Alternatively, you can dip into any water-based paints like watercolors or gouache. Permanent or waterproof pens won't blend in this way.

With both methods, the new color you've dipped into gradually runs out and the original color returns. Rinse your pen under water once you've finished to clean off the second color. If you are using a paintbrush, load your brush with paint or ink and start writing. When you start to run out, instead of dipping back into the same color, dip into a different color and carry on writing. The colors will blend as you work. Alternatively, dip from color to water. This will dilute the color you are writing with, creating a faded effect. It's easiest to do this with a water brush, as the water brush will automatically add water, diluting the color as you write.

This is a color wheel. Blend colors next to each other like yellow and blue, or red and blue, and you will get a third color. Blend colors that are opposite each other and you tend to get a murky brown.

Tip

Work with a smooth, rhythmic movement and don't rush. Paint each letter a stroke at a time. Experiment and have fun. You will quickly learn what colors do and don't work together.

YouTube
Kirsten Burke Calligraphy
Brush Secrets – Color Blending

Creating Compositions

When you first start creating a composition, work in pencil and write your quote out very roughly on paper. Split the words into just one, two or three per line.

Think about the 'hero' words of the quote. These are the words you want to stand out, then start to design a layout, making those words bigger than the others. The joining words like 'and', 'the', 'of' and 'but' could be much smaller.

You want your viewer to be able to glance at your piece and instantly get a sense of what it's about, so think about the meaning of the words and which ones are important.

Think too, about whether you want your design to be portrait or landscape.

Next, look at the areas where your descenders drop down and ascenders go up, leaving gaps.

Now you can make the words 'bounce' and fill those gaps. Each letter will start to take on its own character. The same letter might be different each time it appears in your piece depending on the letters it's positioned next to. They don't need to look the same. You're making an illustration, which just happens to be made with letterforms.

Drawing your design first in pencil allows you to play around with it. Extend some letters or reduce others so that they tuck into the spaces and form an attractive composition. Don't worry about drawing the thick and thins of the letters at this first stage.

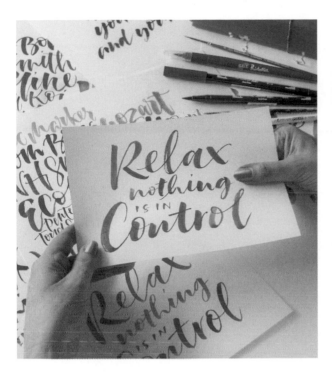

Once you have a design you're happy with, work it up to the scale of the tool you want to use. If you're using a large brush pen, your pencil work needs to be big enough that you can work over it with that size pen. Trying to write over very small pencil letters with a large brush won't work.

It's a good idea to use rough paper that is the same size as the finished card or artwork that you want to create to make sure that all your words will fit. Now you can begin to create your thick and thin strokes by going over the pencil marks with the brush or pen. You can use different-sized tools for different-sized words and think about color to make words stand out.

Play around with your design until you're happy.

Alternatively, use a 'lightpad'. This is a small, flat LED screen that you can use for tracing. Every home should have one and they start at $18.

By laying my pencil 'rough' onto the screen and flicking on the light, I can clearly see my own guides appearing through the card on top. I'm then able to trace over it, so no need to get rid of those pencil marks with a rubber and risk smudging the ink!

It also means that all I have to think about is the thick and thins of my lettering, as the layout is already there for me to follow.

Practice Makes Perfect

Have a go at blending your own color combos.

Relax
Control

Practice Makes Perfect

Art Card 4

Go over the gray lettering below, then try doing it again on the pull-out art card at the back.

Relax
nothing
IS IN
Control
BUDDHA

Breaking the Rules

Secret 8

The secret to breaking the rules is that you must make sure your overall piece is balanced; otherwise you'll end up with a crazy, modern mess! You can break a few rules in one piece of artwork, as modern brush calligraphy is meant to be expressive and creative, but whatever rules you are breaking, make sure you apply them evenly throughout your piece.

Project 5

Skills:
Bending the rules
Adding a flourish

The magic of brush calligraphy is that you can create the mood by the way you style your lettering. A piece that's about the garden could have a floaty, whimsical style of lettering; while a poem about determination might use a much bolder stroke, with strong, thick brushwork and a solid, upright lettering style. The rules you have learned about the way a letter is formed will help you now, as we are about to bend them to make lettering that has a contemporary edge.

Smooth Paper Rule
In this project, we are going to experiment with more expressive styles of brush lettering. Try working with a water brush or a paintbrush or a flexible fibre tip brush pen if you haven't yet. As they are extremely flexible, the contrast between the thick and thin lines you create will be much more dramatic than when you use a felt brush pen. Try working on textured watercolor paper, which will make your letter strokes crack and break up for dramatic effects. Felt brush pens won't tolerate such a rough surface.

Angle Rule
Instead of following the rule, working with a consistent angle, try changing the angle to inject more energy into your artwork. Although in the word below the angle sways back and forth, the calligraphy as a whole is balanced.

The blue lines show the angle of each letter. They each have a different angle, but it works if the whole piece sways back and forth evenly.

YouTube
Kirsten Burke Calligraphy
Brush Secrets – Breaking the Rules

Slow and Deliberate Rule

Your lettering can become wonderfully expressive if you make your strokes quickly. I prefer to go slowly most of the time, but for an edgy vibe, try going faster. This may well make the lines crack, give you splatters on your page and some 'happy accidents'. Although it looks easy, this can be extremely tricky to get right, so plan your composition carefully and if you can, use a lightpad to help keep those fast brushstrokes looking cool, not messy.

Downwards Pressure Rule

The pressure you apply can be mixed up, too. Now you're confident with the pressure being on the downstrokes, and a light upstroke, let's throw a spanner in the works! Because a brush pen or a brush makes quite a thick line, if you always put pressure on the downstroke, your lettering can start to look rather heavy. By bending this rule you can add more style to your lettering. The trick is to keep your pressure light on only *some* of the downstrokes. This works brilliantly when there's a double letter or two similar shapes together in a word. Again, for this to be successful, you must balance your overall piece. Make some of your downstrokes thin to mix it up a bit, but never go upwards with a thick stroke! That's a rule that can't be broken.

Compare how different this word looks by breaking the 'pressure' rule and adding a touch of 'bounce'. Have a go tracing over these gray versions.

Here, the word is written with the pressure applied for every downstroke.

Here, the pressure isn't applied on the 'a', which makes the word look lighter.

This version keeps the 'a' light and also makes the double overturn on the 'm' light.

Flourishes

Flourishes can be as simple as adding in extra curves to the end or beginning of letters, or they can be a main decorative element. Take care to avoid flourishes looking like a letter. You are writing with your wrist fixed and making the movement from your shoulder. By doing this, the swirls and curls you make will be smooth. Use the tips of your fingers to steady your hand, so that you can glide over the paper with a delicate touch.

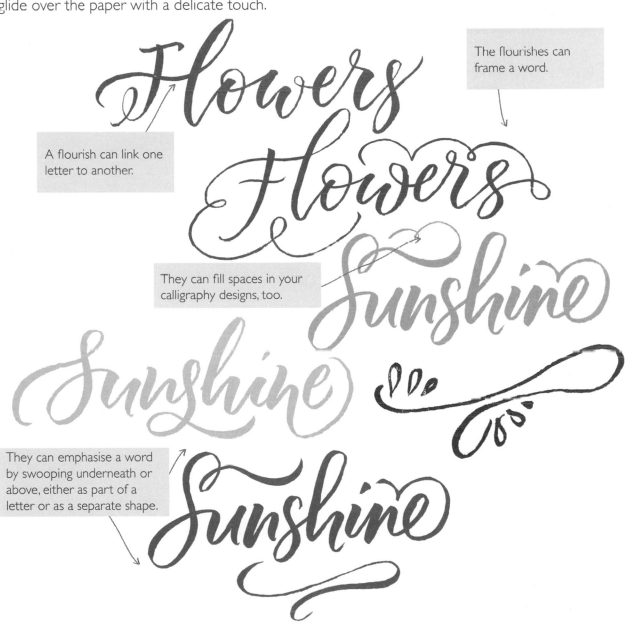

The flourishes can frame a word.

A flourish can link one letter to another.

They can fill spaces in your calligraphy designs, too.

They can emphasise a word by swooping underneath or above, either as part of a letter or as a separate shape.

Art Card 5

Go over the gray lettering below, then try doing it again on the pull-out art card at the back.

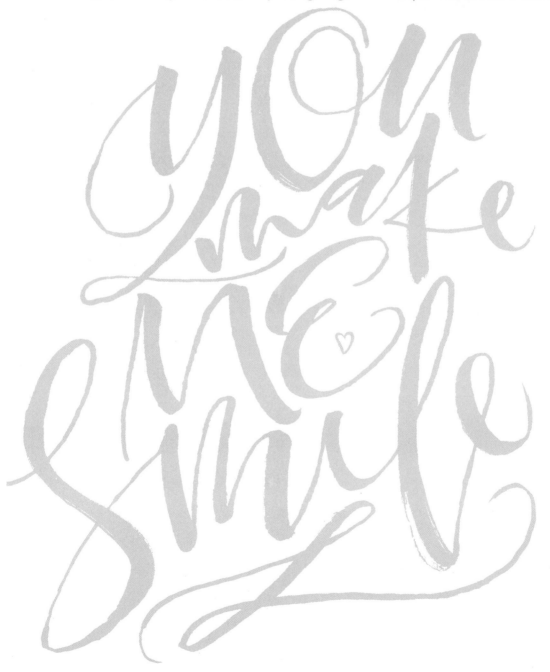

Calligraphy into Shapes

Secret 9

,, This is such a fun thing to try. The secret to making it work is to keep your shape simple and make sure that you 'hug' the outline as much as possible. Find a silhouette that is instantly recognisable, then with your letters, touch the edges and stretch the curves around your shape. Reduce the spaces as much as possible without making your calligraphy look squashed.

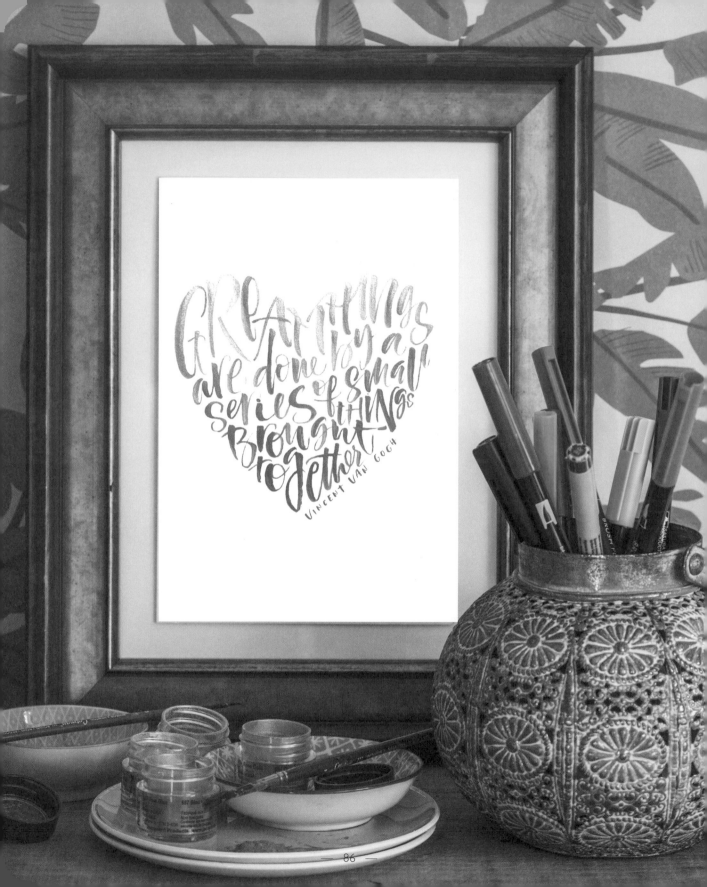

Great things are done by a series of small things brought together

VINCENT VAN GOGH

Project 6

Skills:

Creating shapes with lettering

The first thing you need to do is to find a shape that is easy to recognise as a silhouette and then when you fill it with letters, you can't go wrong. Simple shapes like a circle, heart, square or diamond are perfect for beginners. A Christmas tree, bottle, wine glass or even an Easter bunny can work brilliantly when you're feeling more adventurous.

Step One

Draw your shape out at roughly the size you want your finished work to be.

Step Two

Pencil in your quote, so that it fits into the shape. You will need to squeeze some letters and stretch others. The crucial thing is to 'hug' the outline of your shape as closely as possible.

Step Three

Using a lightpad or a window, gently trace your rough outline as a neat version. Use the brush pen of your choice and go over your drawing, applying the thick and thin strokes to the letters. You may want to keep some downstrokes thin if you feel that it helps the balance of the composition. Remember not to use a thick line on an upstroke. I will often trace my work two or three times until I'm happy. By adding the brushwork in, you can see where the weight of the letters go and where they might need adjusting. Have a go at mixing some metallics with a color if you have them. I have used Finetec gold with some burgundy ink for my version.

Step Four

Frame your masterpiece!

 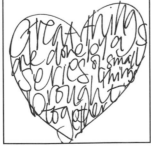 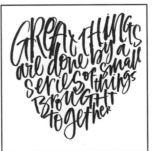 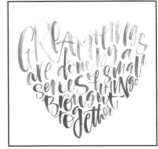

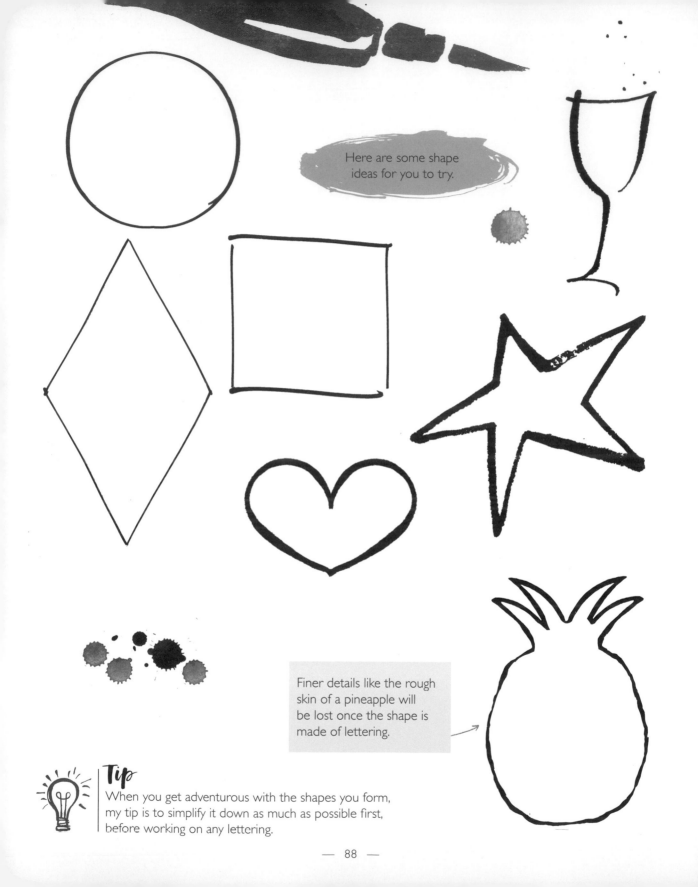

Here are some shape ideas for you to try.

Finer details like the rough skin of a pineapple will be lost once the shape is made of lettering.

Tip
When you get adventurous with the shapes you form, my tip is to simplify it down as much as possible first, before working on any lettering.

Metallics

Working in metallics is such an effective way to give your work that 'wow' factor – I'm a big fan, especially on dark cards.

There are metallic brush pens such as Posca and Kuretake, which come in a selection of shades, and STA if you prefer a more flexible tip.

If you fancy giving a water brush or paintbrush a go, many inks need constant mixing to keep their particles combined, so I recommend Finetec metallics. They are solid watercolor blocks, but the shine they give is as if you have written in gold leaf – you just add water and stir.

You can combine any water-based inks or paint with your metallics and your colors will turn metallic, too.

Art Card 6

Go over the gray lettering below, then try doing it again on the pull-out art card at the back.

GREAT THINGS are done by a series of small things brought together

VINCENT VAN GOGH

Writing on Objects

Secret 10

Writing on objects is quite a leap from writing on a flat piece of paper. They may have lumps and bumps, roll around, be fragile and basically give you a whole new set of problems to solve. So, first make sure you secure the object as much as possible, then the secret to writing on an object successfully is to try to find a 'prop' to lean on. This 'prop' needs to be something that's the same height as the object you are working on, which will allow you to get into the right position to work.

Project 7

Skills:

Writing onto Objects

Writing onto objects is amazingly effective and you could give a friend a personalised mug or glass as a gift, or make a creative version of a place card on a stone. However, because of their irregular surfaces and shapes, getting your lettering to look good can be a challenge. For any 3D object, secure it as best you can. An egg or a stone could be placed in Play-Doh, or in an egg cup. Next, find a 'prop' to lean on – something to rest your arm on. This is my secret to fabulous 'live' calligraphy when I work at events that require me to write on oddly shaped bottles or boxes decorated with ribbons. By propping up my arm with a box to a similar height as the object I'm working on, my hand will be steady so I don't need to try to lean on the object itself, which might be wobbly.

Always do a few tests before you work on the real thing, as different products give different results, even though they may say they are suitable for that surface. Some pens hardly show up at all, or wash off with water. So check that what you're planning to use will give you the result you want. Using acrylic paints makes your lettering waterproof, so it will survive outside.

Working on Fabric

Because of the stretchy, movable nature of fabrics, pull the section you are working on as tight as you can, so it doesn't pucker up as you write. Sharpie Stained pens are fantastic for writing on light colored fabrics and come in a pack of eight vibrant colors. They have a felt brush tip end that is easy to use, so your thick and thin lines come out well. Posca pens (both brush and bullet tipped) work on fabric too, though you will need to go over your letters a few times to build up the color depending on the effect you want to achieve. Because these have a very flexible fibre brush tip, I would recommend using the bullet tip and doing 'faux' calligraphy if you want your lettering to have solid color. Iron your fabric on the reverse before washing, to make it washable and fade resistant.

Working on Metal, Plastic, Glass and Stone

Posca pens are great. They come in a wide range of colors (including metallics), with brush tips and bullet tips, in various thicknesses. To make sure your writing is permanent, I'd recommend applying a couple of layers of varnish. If you make a mistake on a smooth surface, you can use a damp cloth to wipe it off quickly before it dries – then have another go!

Ceramic/Porcelain

Posca brush pens and Edding porcelain brush pens work well. Edding have less flexible tips, so are easier to control. When you've finished with them, both need to be heated in an oven at 160°C for 25 minutes.

Faux Calligraphy

You may find that using a brush pen on certain surfaces just doesn't give you the results you need. You may have to use an alternative like a brush and acrylic paints, which have a kind of 'plastic', shiny finish to them. This is especially true on porous surfaces.

Sometimes you need to go over the color a few times to make it stand out and this can make your lettering start to look messy. A good workaround for this is to use 'faux' calligraphy.

Faux calligraphy is a technique for making your lettering look like calligraphy, without doing any.

By writing the word or phrase out at the right scale with a bullet tipped pen (suitable for the surface you are working on) and then adding another parallel line to just the downstrokes, you can thicken them up by hand, like your brush pen would do naturally.

Once you color in the spaces these outlines create, you have an effect that resembles calligraphy, which may give better results when working onto fabric. It can also work if you want to write out lettering that is larger than any brush or pen will allow, like on a poster or house signage.

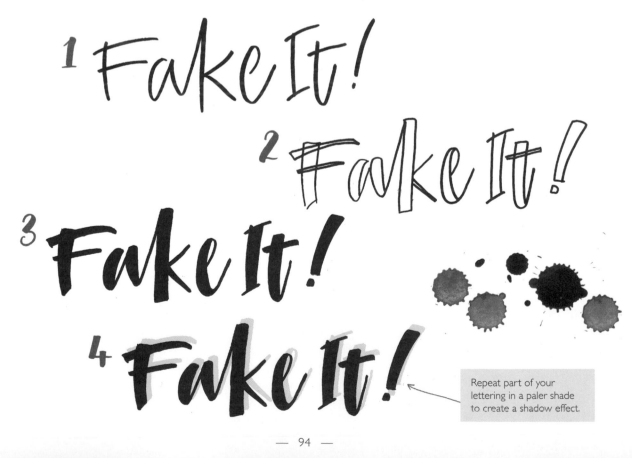

1 Fake It!

2 Fake It!

3 Fake It!

4 Fake It!

Repeat part of your lettering in a paler shade to create a shadow effect.

THOUGH She be but LITTLE SHE ♡ is FIERCE

Here's a layout written with a bullet tipped pen. Try thickening up the downstrokes yourself to make 'faux' calligraphy.

Art Card 7

Go over the gray lettering below, then try doing it again on the pull-out art card at the back.

THOUGH
SHE BE BUT
LITTLE
SHE ♥ IS
FIERCE

WILLIAM SHAKESPEARE

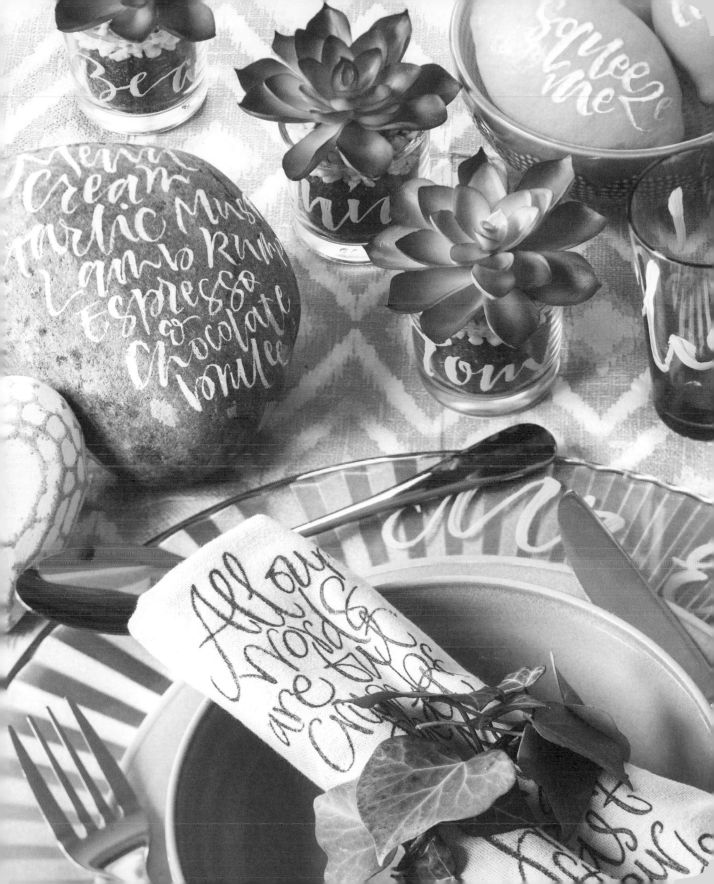

Remember to look back at the
first pages in this book to see
how much your calligraphy has
improved!

How
lovel

To Sum Up!

Secret 12

Rules and proportions are important to understand,
but the final secret to great brush calligraphy is to
play with them to make lettering that's quirky and full
of character. Don't overthink it — see what happens.
Use the skills and secrets you have learned here
to balance and perfect your lettering.
Let your personality shine through.
Happy brush lettering!

Practice Makes Perfect

Practice Makes Perfect

Practice Makes Perfect

Practice Makes Perfect

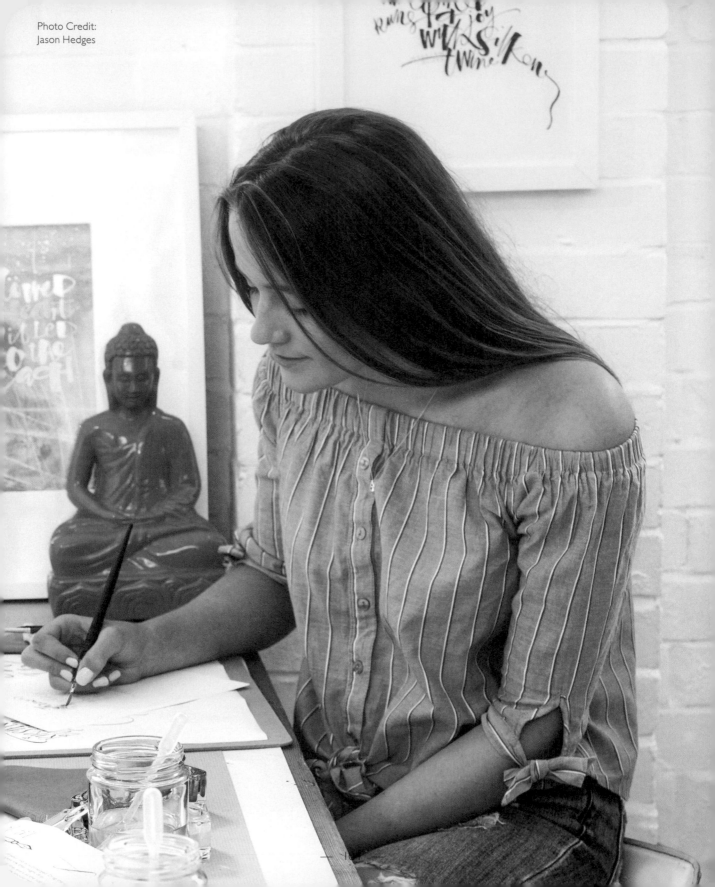

Workshops

Brush calligraphy workshops are becoming increasingly popular and are popping up all over the country. If you can get to a workshop near you, I can't recommend it enough.

When I teach a workshop, I'm able to show students exactly where to make minor adjustments to their angles and positioning, which can make all the difference to picking up calligraphy quickly. Most teachers will also do demonstrations, so that you can watch them and see what to do at first hand. There's no better way to learn than to copy an expert.

We wanted this book to be as near as we could to the workshops that we teachy. The best solution we could think of to support the book was to create the YouTube video tutorials that are labelled throughout the book, so that you can watch me from the comfort of your own home – your very own tutorial!

These videos mean that you can watch me demonstrate how to do some of the skills that might be harder to grasp, so if you haven't been on to my YouTube channel yet, go and visit and subscribe to it. I think it will really help you. I will be putting up new tutorials periodically as new tools and products come on the market. It's always great to try out new things, so that you are motivated and inspired to keep going.

Another great thing about attending a brush lettering workshop is that you have the opportunity to try out a broad selection of all the different pens on the market and work with them, so that you can see which ones you like the best and, more importantly, see which ones you don't.

Bring the family and plan a weekend around your calligraphy workshop! Learning together means you can chat about your lettering and gain inspiration from each other.

Some of my students have set up evening meets, where they get together to practise their lettering, so it can be a great way of making new friends. You'll feel relaxed and energised, and you'll be amazed at how much you can create after just one workshop. The perfect escape!

Suppliers

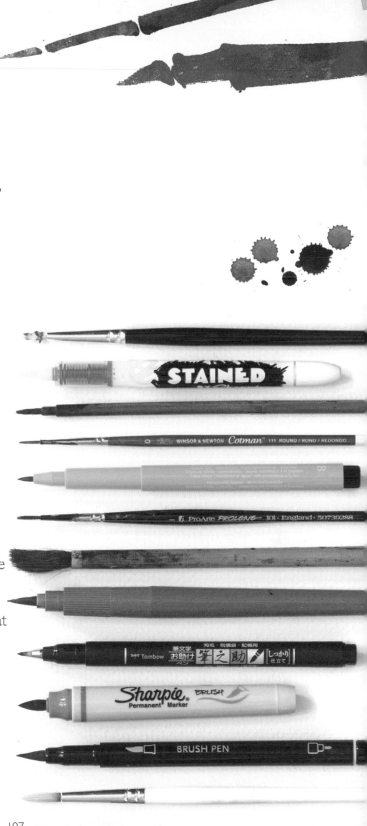

In Asia and the Middle East, brush lettering has been part of the culture for hundreds of years. Suppliers in these countries developed brush pens years ago as a user-friendly, modern alternative to their own traditional style brushes, so that the need for ink and 'dipping' was eliminated. As a result, there are lots of different brands of Japanese brush pens on the market from **Tombow**, **Sakura** and **Kuretake**.

US suppliers are rushing to develop and bring out new products all the time to cope with demand. So, when you are ready to buy some brush lettering tools, my advice would be to look online or call your local art shop or stationery supplier to see what the latest products are. My *Essential Brush Lettering Kit* has a dual-tip brush pen, a water brush, inks and a paintbrush — everything you need when getting started to go with this book. These kits make fantastic gifts and will hopefully develop a lifelong interest for hand lettering in both adults and children.

You can buy online at **Amazon** or **Etsy**, search Kirsten Burke Calligraphy, or on my own website **www.kirstenburke.co.uk** where I stock my favorite pens. At the time of writing, the following other online suppliers also offer a great range of pens and calligraphic supplies:

www.johnnealbooks.com
www.michaels.com
www.paperinkarts.com
www.dickblick.com

Our Story

I can hardly believe that I've been a professional calligrapher for more than 20 years.
After getting my degree in graphic design, I did a postgraduate course in traditional calligraphy, illuminated lettering, gilding and bookbinding.

I spent a year learning how to use a broad-edged nib to create the most exquisitely perfect lettering, with every letter and every angle identical, but what I loved most was making bold, vibrant artworks that took the meaning of the words and turned them into art – making pictures out of words.

In 1995, I applied to the Crafts Council for a grant to set up a calligraphy business with my business partner, Jill. We wanted to challenge traditional perceptions of calligraphy by creating striking modern designs, sometimes illegible so that the meaning of a piece was conveyed by the whole artwork, not just the words.

We wanted to put calligraphy on absolutely everything – artworks in galleries, greetings cards, buildings and clothes, but we were turned down because it was viewed that we were being too diverse. We were advised to focus on just one thing, otherwise our business would fail. Fast-forwards 20 or so years and we have now had a greetings card range that has sold more than 10 million cards, wedding stationery designs that have helped over 30,000 brides and design work on everything from billboards for West End musicals to writing in chocolate body butter! It's this diversity of our work that excites us.

Although my early work concentrated on using traditional tools like the broad-edged nib, and automatic and ruling pens, my big break didn't come until I was commissioned to create a 40ft mural for Shakespeare's Globe, Bankside, London. The giant size of the artwork meant that I couldn't work with my usual tools and had to come up with a new way of working. I decided to hand paint my lettering with a simple decorator's paintbrush and so began my love of brush lettering.

My contemporary lettering style developed from a combination of my traditional work with a nib and the ancient brush lettering practised in the Far East – free-flowing with lots of energy and movement. I played with the rules that I'd learned and broke them to push the boundaries of acceptance.

Over the next few years I won many other public artwork commissions to put my style of modern calligraphy on all types of surfaces and liven up the interior spaces of buildings – on canvases, walls, wooden panels and even windows. The only tool for these jobs was the brush, so I started using it more and more.

The brush pen is the modern version of the ancient brushes and as it's so easy to use, anyone can have a go, so calligraphy workshops have exploded all over the country. One of the best things about calligraphy is that it crosses all age barriers – kids and adults can do it together.

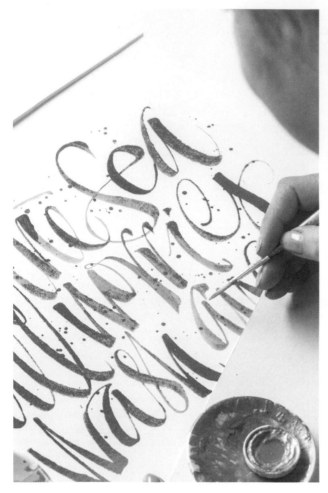

In 2012, Jill and I relocated our business and families from London to the beautiful Witterings on the South coast of England. Since then, our business has expanded and evolved at a rate we could never have anticipated or dreamed of when we left London. We now have a large, dedicated team of calligraphers who share our passion for modern calligraphy, working on events for us all over the country.

On the corporate side, Jill now manages national calligraphy campaigns for a number of high-end luxury brands from cosmetics to fashion, who in their battle to compete with online shopping have turned to calligraphy as a

unique way of adding a bit of theatre and personalisation to their customers' shopping and gifting experiences. Long may it continue!

I believe the main reason that modern calligraphy has become so popular now is that it encourages you to develop your own style, to be yourself. It is therefore the perfect antidote to our increasingly hectic, stressful lives.

While Jill is running the business, I am able to indulge my love of lettering, experimenting with new ideas, while sharing my passion and experience through the workshops that I run for beginners, intermediates and professionals,

as well as children and schools. I am so grateful that I've been given the chance to reach out to new people all over the world through both my books and the advent of platforms like YouTube and social media.

I gain such satisfaction from seeing how quickly people are able to learn this art and how proud they feel when they see their finished piece of work. This is now the third book I've had published and I'm excited about new titles that are in the pipeline.

In a world where the demand on our time is ever increasing, it's so important that we can all carve out time for some mindfulness and creativity, and calligraphy is the perfect solution! I really hope you enjoy this book as much as I have enjoyed writing it.

YouTube: Kirsten Burke Calligraphy
Instagram: kirstenburkedesigns
Twitter: kirstenburkeart
Facebook: kirstenburkedesign
Pinterest: Kirsten Burke Contemporary Calligraphy

Acknowledgements

This book wouldn't have been possible without the help and support of all the people around us. So we would like to take this opportunity to say a massive thank you to everyone who helped with this book – we couldn't have done it without you!

To Kirsty, Nia and the team from Studio Press who've been fantastic to work with. They shared the same dream – to create a series of fun and interactive books to inspire beginners, leaving them eager to learn more.

To Rebecca and Stewart who made it look beautiful. To Amanda, Maisie, Julie, Freya and Ben whose hard work behind the scenes has allowed our business to grow.

To the people who came along to our workshops and allowed us to take photos and videos of them to include in this book.

To all our friends and family, who covered for us so that we could find the time to write another book, and especially to our husbands and children – thank you!

To all you budding brush calligraphers who bought this book – we hope we have helped you fall even more in love with lettering. Keep looking out for more Kirsten Burke titles to come in the future!

Love from,
Kirsten and Jill

Concept & Text: Kirsten Burke and Jill Hembling
Design & Illustrations: Kirsten Burke
Photography: Stewart Grant
Video Production: Flutterby Films
Styling: Rebecca Sharrod
Creative Assistant: Maisie Minett

Believe you can and you're halfway there

THEODORE ROOSEVELT

the true sign of intelligence is not KNOWLEDGE but imagination

ALBERT EINSTEIN

With freedom, books, flowers, and the moon, who could not be happy?

OSCAR WILDE

Relax
nothing
IS IN
Control
BUDDHA

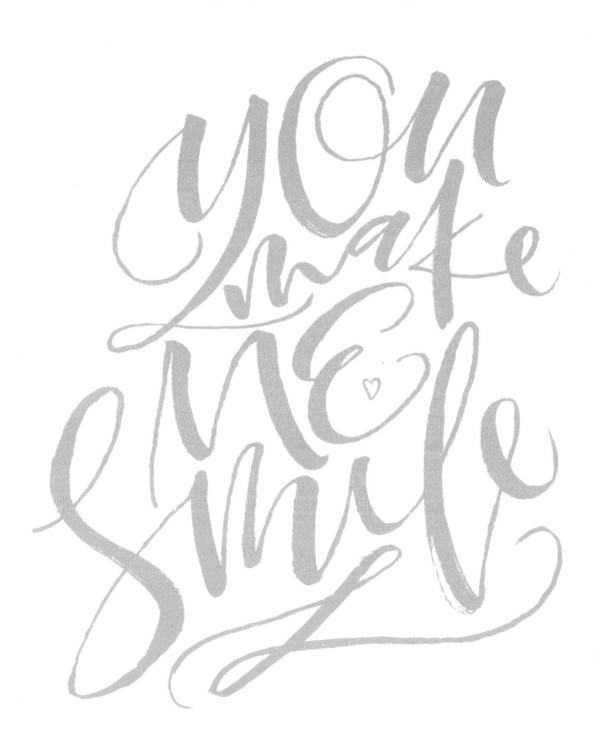

GREAT THINGS are done by a series of small things brought together

VINCENT VAN GOGH

THOUGH
SHE BE BUT
LITTLE
SHE IS
FIERCE

WILLIAM SHAKESPEARE